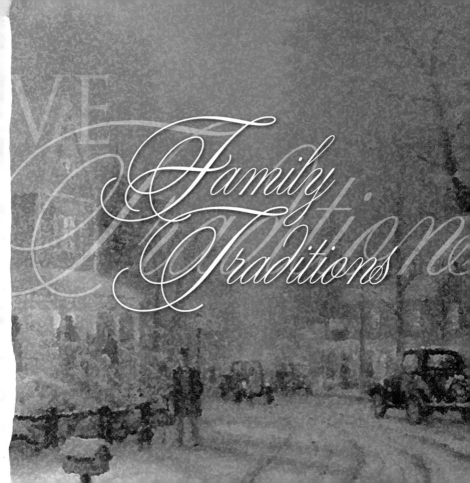

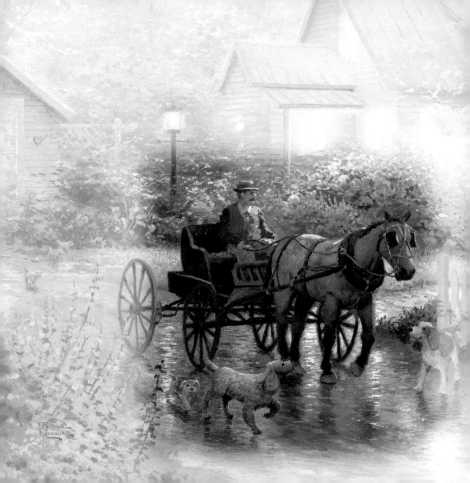

Family Traditions

THOMAS KINKADE

Family Traditions

**Andrews McMeel
Publishing**

Kansas City

THOMAS KINKADE

Family Traditions

ISBN: 0-7407-2233-6
Library of Congress Control Number: 2001095815

Compiled by Kathleen Blease

Thomas Kinkade

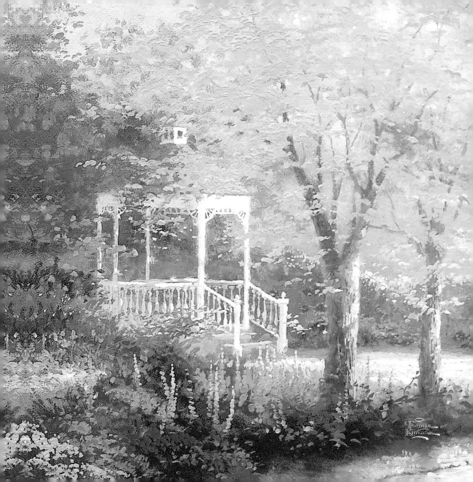

Introduction

It was once said that no man is an island.
Just imagine how life would be without the
comforts and strengths of a family. What would
happen if they were suddenly taken away?
Without them, you wouldn't have a place to
learn about life. Here, within the family, is where
we (children and adults) try on new wings, stretch the
mind, hang new hopes, and live out dreams—
even before tackling the real world.

There's no greater comfort to a young child than a family. And there's no greater joy to a parent than building a family that is sustaining and nurturing. Family is a funny word. The dictionary defines it as a group of people who share a blood lineage. But so many strong, healthy families are made of people who are not related at all—those who are bonded by joys! Whatever your family tree looks like, whoever you consider your family to be, without them life would be a steep cliff. Family is the tether

and the spikes that keep our feet safely planted while we look out over the glorious world. What a blessing family is! A remarkable invention: wings and roots, inseparable! Created by God and given to us as His gift.

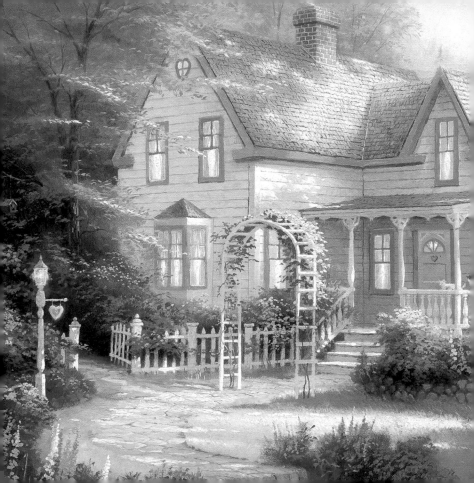

Home.

Is there a more
evocative word
in all the
English language?

—*Thomas Kinkade*

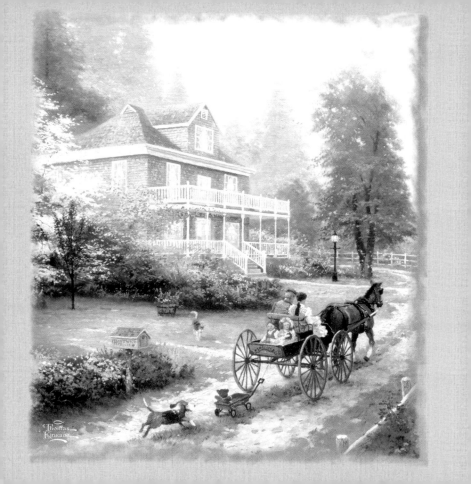

Picture a world

the way it was meant to be.
Where work and leisure
take their proper place,
where faith and hope
and love abide,
and new possibilities
forever bloom.

—*Thomas Kinkade*

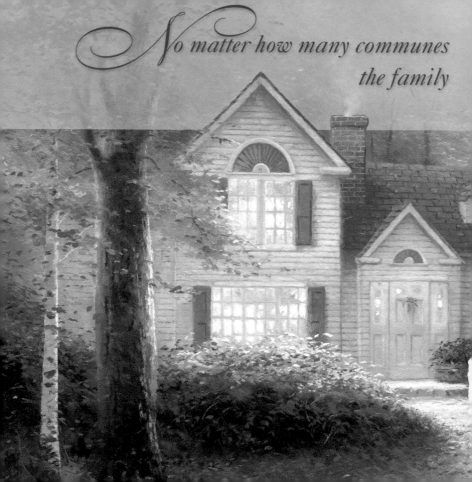

No matter how many communes the family

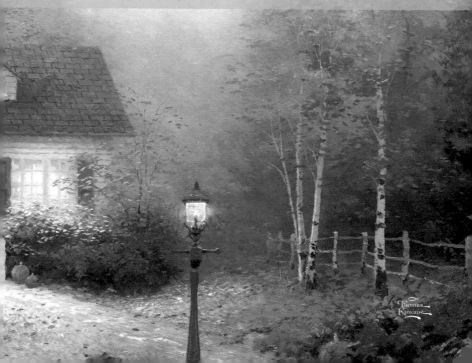

*anybody invents,
always creeps back.*

—Margaret Mead

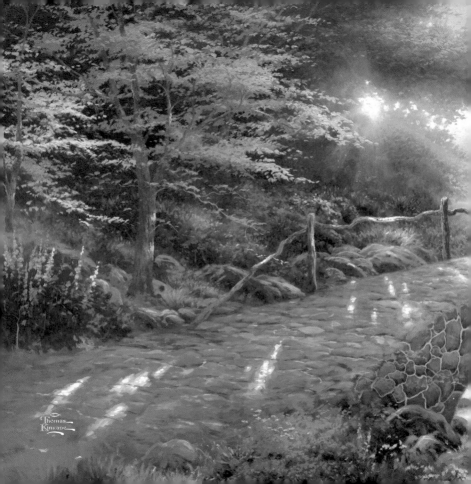

Fill your home with beautiful aromas.
Have you ever noticed how
a single whiff of a familiar fragrance
has the power to carry you instantly
back to your childhood?

— *Thomas Kinkade*

He is rich or poor according to what he is, not according to what he has.

—Henry Ward Beecher

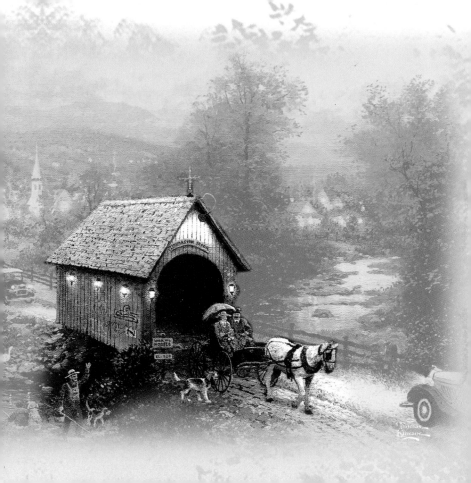

Make home a priority in life. Invest time and energy in creating a warm refuge for yourself and your family, a place where everyone can feel nurtured and cared for, safe and protected, free to be exactly who you are.

—Thomas Kinkade

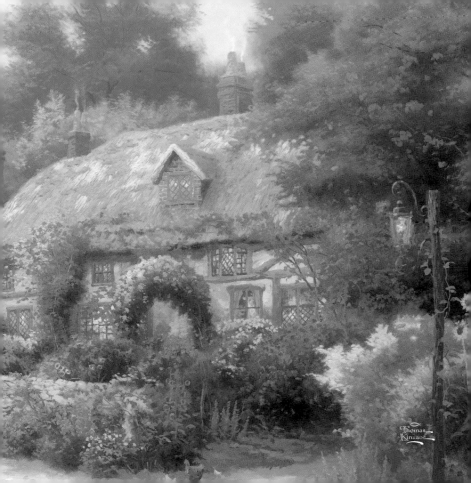

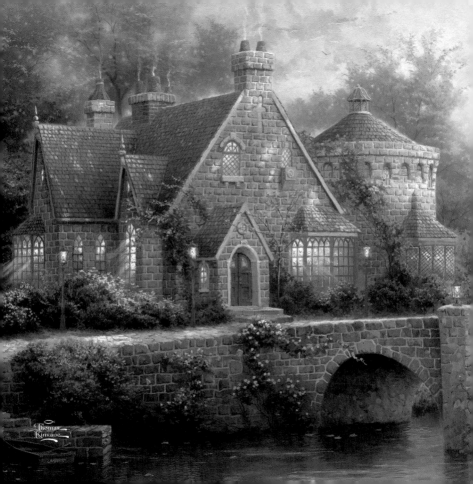

Ever since I was a boy, my dreams of travel and adventure have been balanced with a powerful sense of home, the vision of a warm center for all my roamings, the notion of a glowing hearth where I could retire after a hard day's journey to rest, to be renewed, to remind myself of who I am and what I love.

—*Thomas Kinkade*

Evolve a sense of what you were put on this earth to do and all your other decisions will begin to fall into place.

—*Thomas Kinkade*

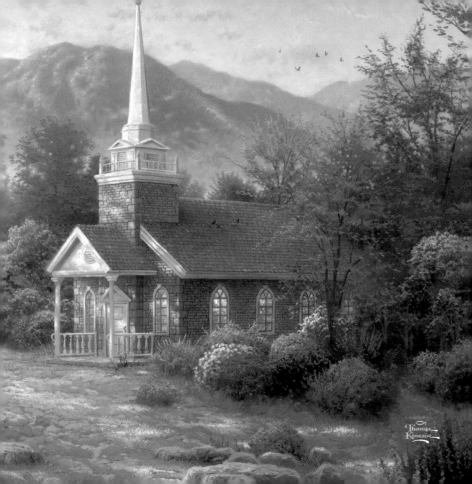

Thomas Kinkade

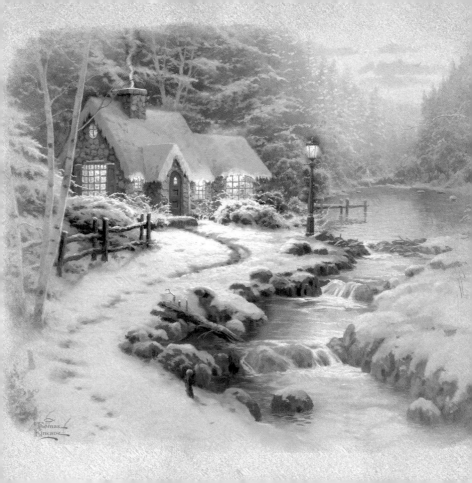

He that raises a large family does, indeed, while he lives to observe them, stand a broader mark for sorrow; but then he stands a broader mark for pleasure too.

—Benjamin Franklin

When thinking about composing your life,
begin by making some foundational decisions
about how you'll spend your time, where you'll
invest your energy, and why you are

doing it all in the first place.

—Thomas Kinkade

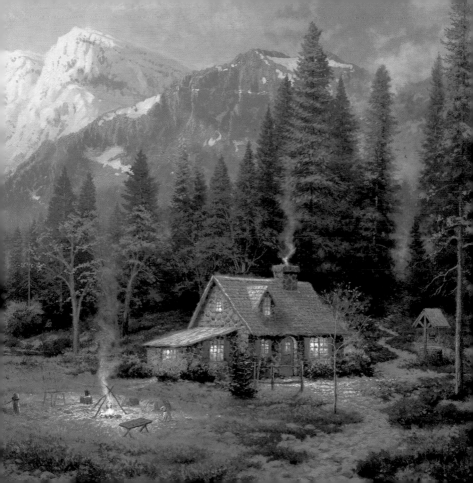

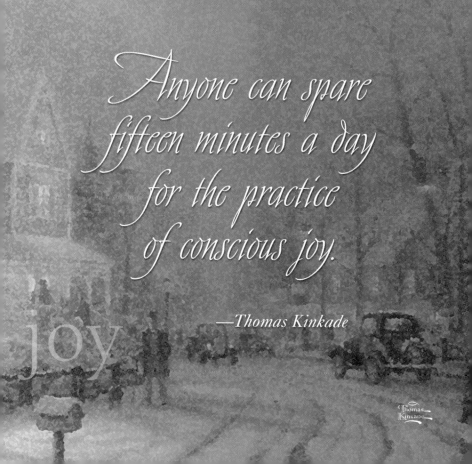

*Anyone can spare
fifteen minutes a day
for the practice
of conscious joy.*

—Thomas Kinkade

joy

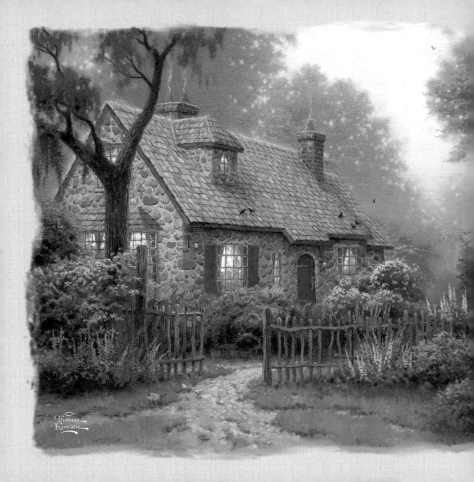

A happy family
is but an
earlier heaven.

— *Sir John Bowring*

Watch for surprises.
A tree full of butterflies…
a fresh breeze on a hot day…
a simple unexpected sense
that all is well.

—*Thomas Kinkade*

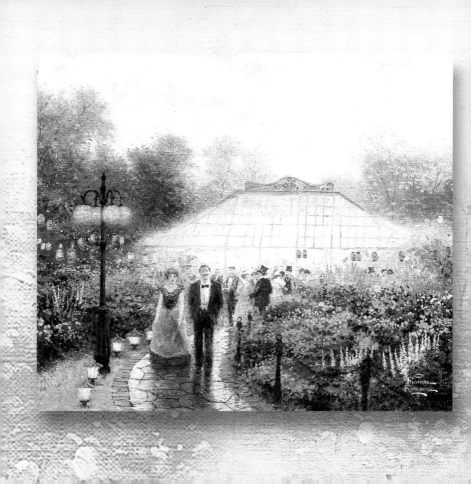

It is the security that comes from truly being at home that gives one the courage and freedom to travel, to seek adventure.

—Thomas Kinkade

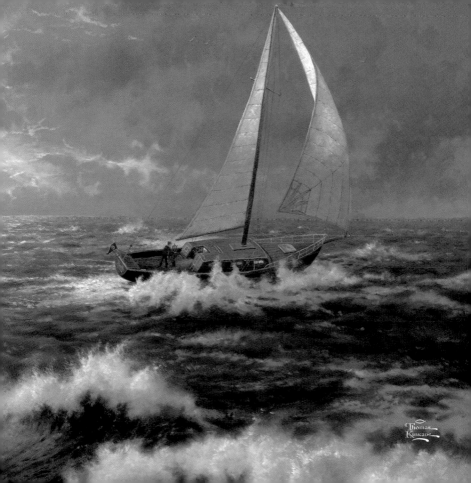

Such is the patriot's boast,

His first, best

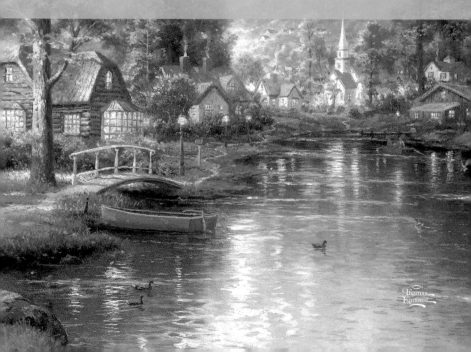

where'er we roam,
country ever is at home.

—*Oliver Goldsmith*

I can still picture the floor plan of the house where I lived as an older child; even today I could find my way around it in the dark. (Couldn't you do the same?)

—Thomas Kinkade

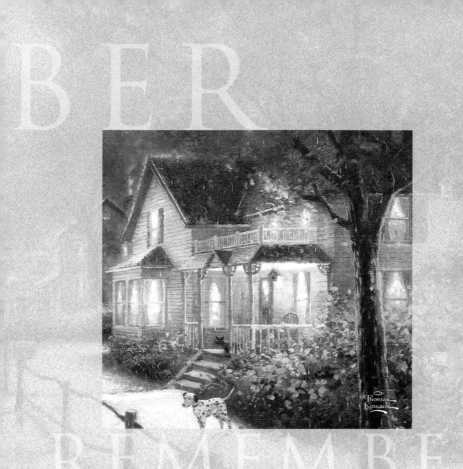

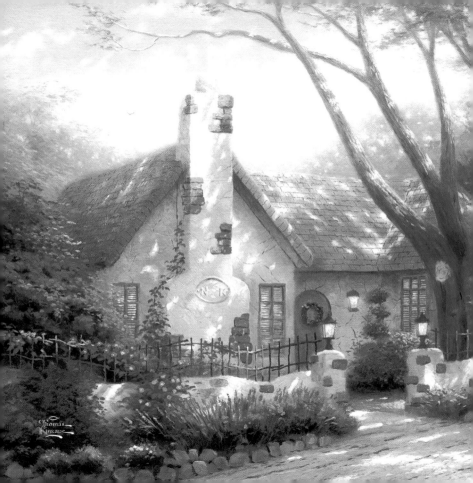

*Passion and joy
are intimately connected.*

—Thomas Kinkade

Sit down with a sheet of paper and try to feel is the primary focus of your life, what you were born to do.

capture, in about ten words, what you
what is important to you,

—*Thomas Kinkade*

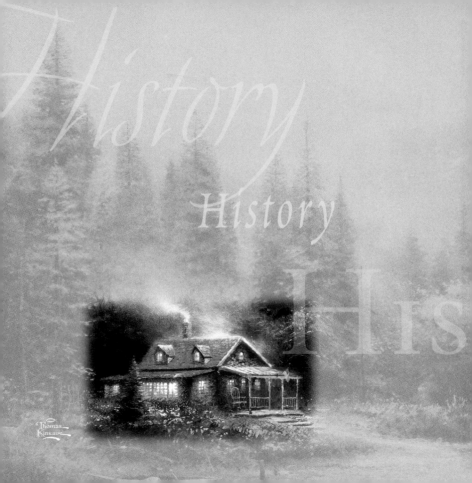

There is history
in all men's lives.

—William Shakespeare

REMEMBER lazy summer days of sipping lemonade and skipping stones or just sitting, being bored? Re-creating that feeling for even a short time can nurture the childlike spirit inside your heart.

—Thomas Kinkade

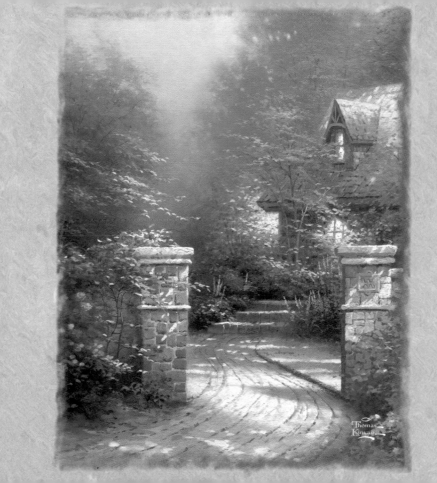

Thomas
Kinkade

Simple comforts—from the warmth of a woolly afghan to

can reinforce your sense that all

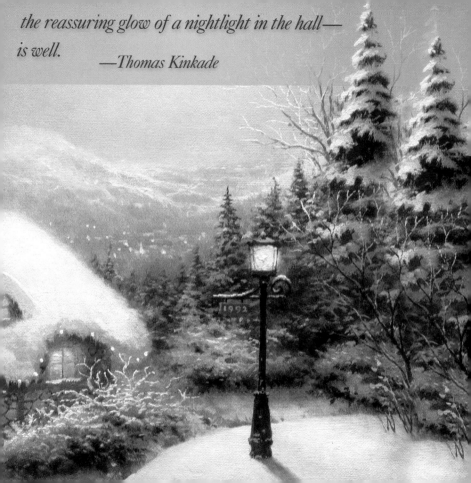

the reassuring glow of a nightlight in the hall—
is well.
　　　　　—Thomas Kinkade

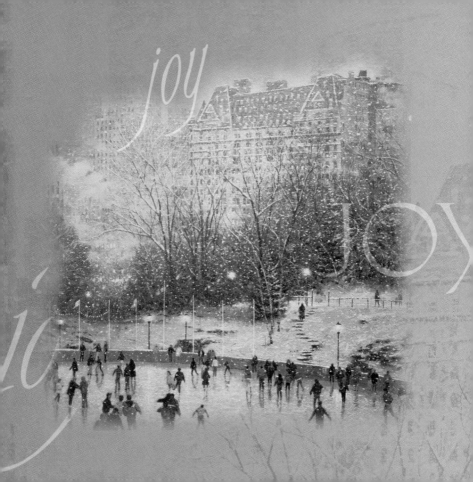

If we want to discover a childlike joy, we need to practice looking at the opportunities of the moment and saying, "Let's do it now!"

—*Thomas Kinkade*

We need to surround ourselves and our families with objects and ideas and activities that please and excite our senses, that make us smile, that provide a soothing balm of comfort for our days.

—Thomas Kinkade

Backward, turn backward,

O Time, in our flight,

Make me a child again

Just for tonight.

—Elizabeth Akers Allen

Thomas Kinkade

\mathcal{W}e live far more joyfully
when we allow ourselves
a playful spirit
in our work
and when we inject
meaning and purpose
into our play.

—Thomas Kinkade

A funny remark from a child, a spectacular a fresh breeze on a hot day, or just a simple that all is well—any of these experiences if you let yourself receive it.

cloud formation, a tree full of butterflies,
unexpected sense
can be a gift of joy

—*Thomas Kinkade*

Shape the total atmosphere of your home and your workspace, wrapping beauty around yourself through the colors and textures you choose, the objects you place on walls and floors, the music you play, the bedding you sleep in nightly, even the dishes that frame the meals you eat.

—Thomas Kinkade

Thomas
Kinkade

But every house where $Love$ abides
And $Friendship$ is a guest,
Is surely home, and home-sweet-home;
For there the heart can rest.

—Henry Van Dyke

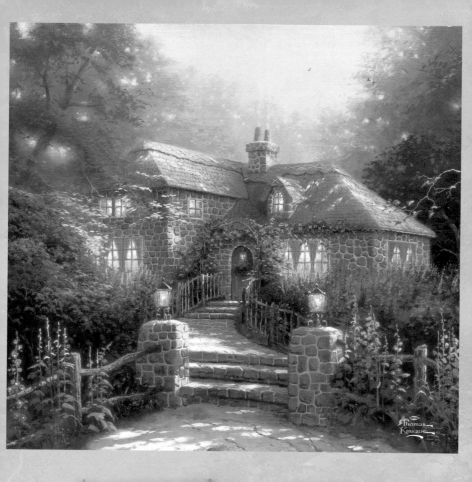

Thomas Kinkade

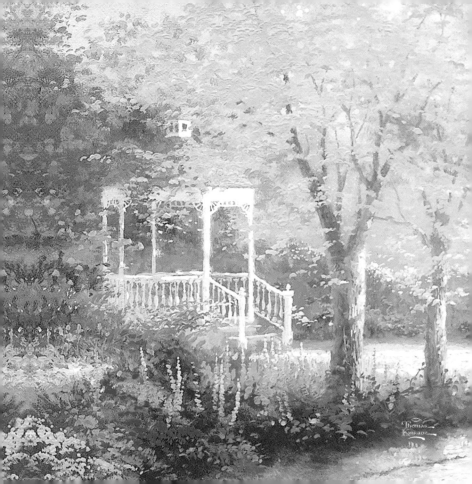

*Every place you go
life teaches you something
about the fine art of
making yourself at home.*

—*Thomas Kinkade*

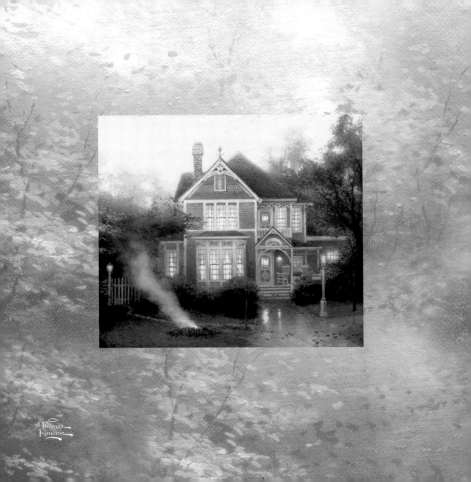

One good way to foster the awareness
of all the good in your home
is actually to plan a house blessing—
a time when you and your family
and friends walk through the rooms
of the home and offer special prayers
of thanksgiving and benediction.

—*Thomas Kinkade*

Offer it all,

even the walls and floors

and ceiling, to God's care.

I believe you'll find that this time

of blessing provides you with a

heightened awareness and a deeper

love of the gift that is your home.

—Thomas Kinkade

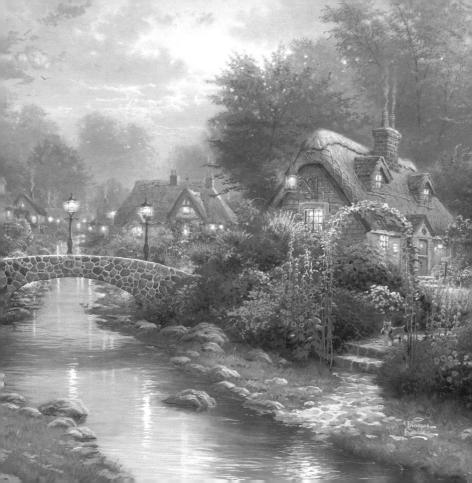
Thomas Kinkade

One of the most meaningful ways we have found to shape our home and make it uniquely ours is to establish and uphold family rituals. We have found that these deliberately repeated experiences are especially effective ways of building a shared history and nurturing our family relationships.

—*Thomas Kinkade*

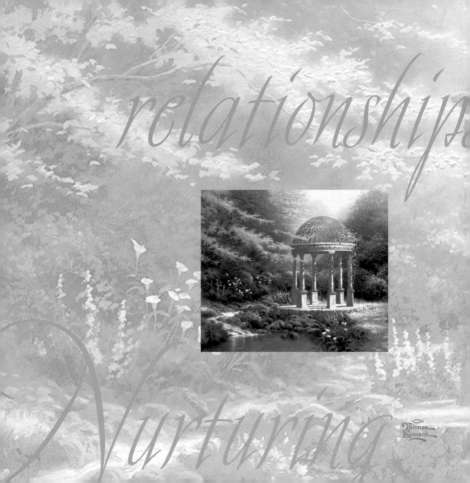

relationship

Nurturing

Thomas
Kinkade

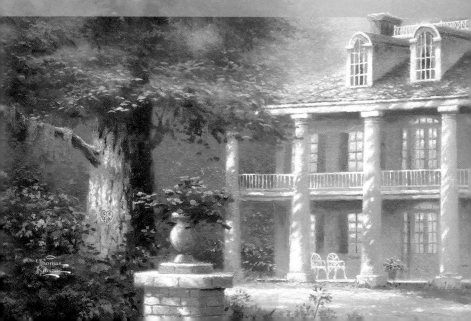

Having someplace to go is home.
Having someone

to love is family.
Having both is a blessing.

—*Unknown*

There are only two lasting bequests
we can hope to give our children.
One of these is roots, the other, wings.

—*Hodding Carter*

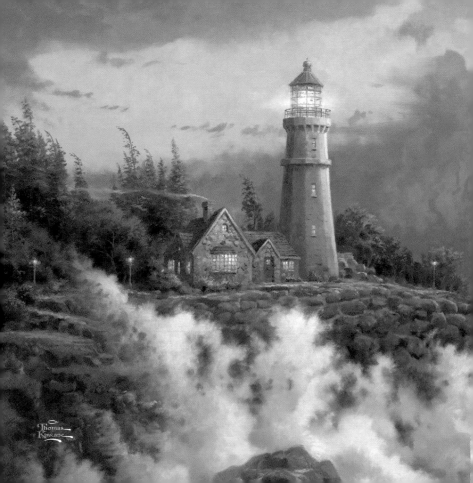

The little world of childhood

with its familiar surroundings

is a model of the

greater world.

— *Carl Jung*

Feelings of worth can flourish only in an atmosphere where individual differences are appreciated, mistakes are tolerated, communication is open, and rules are flexible— the kind of atmosphere that is found in a nurturing family.

—Virginia Satir

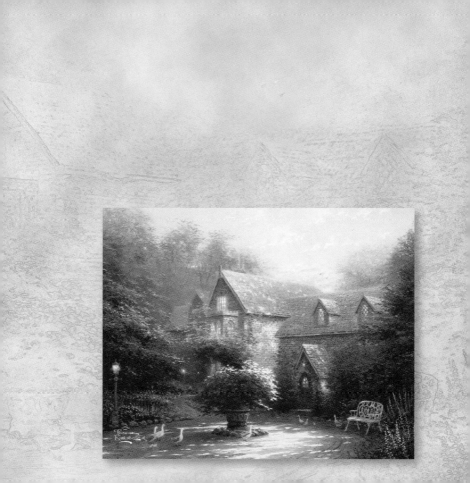

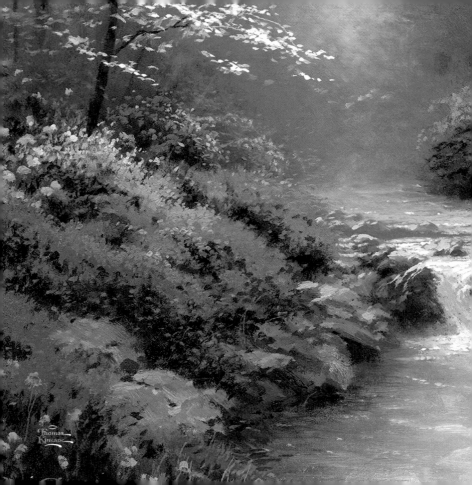

Whether a biological family or an extended family of people attracted to each other based on heart resonance and mutual support, the word "family" implies warmth, a place where the core feelings of the heart are nurtured.

— *Thomas Kinkade*

There is always one moment

in childhood when the door opens

and lets the future in.

—Graham Greene

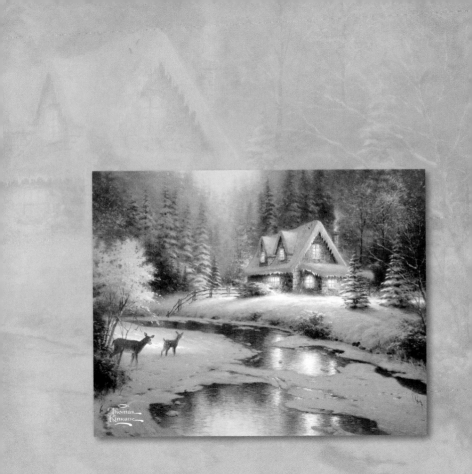

In the rush of schedules and responsibilities and even recreational pursuits, it becomes far too easy to go through life with blinders on, oblivious to (and far too busy for) the joyful surprises waiting to be discovered at any given moment. If you want these little gifts of joy in your life, you may actually have to train yourself to notice them.

—Thomas Kinkade

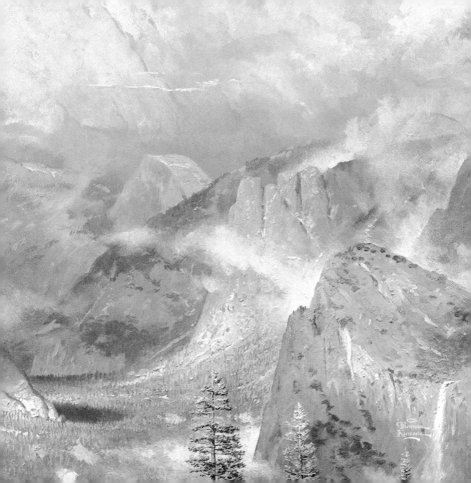

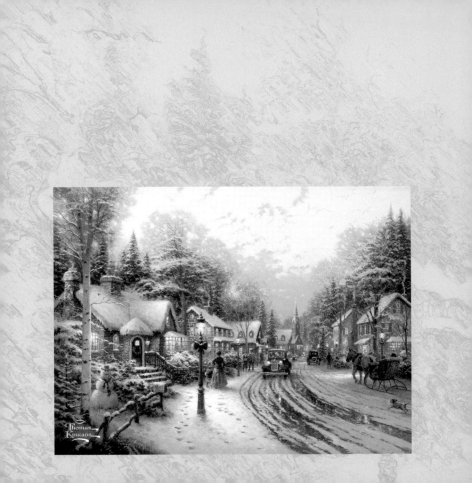

My heart is happy, my mind is free
I had a father who talked with me.

—Hilda Bigelow

We find delight in the
beauty and happiness of children
that makes the heart
too big for the body.

—Ralph Waldo Emerson

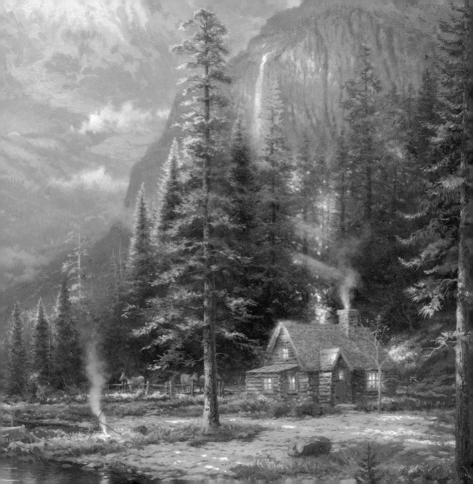

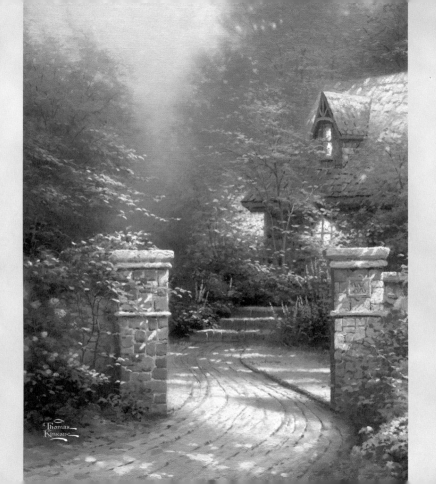

When voices of childhood
are heard on the green
And laughing is heard on the hill,
My heart is at rest within my breast
And everything else is still.

—William Blake

On the basis of experience
I wholeheartedly offer this prescription
for remaining a child at heart:
Have children.

—Thomas Kinkade

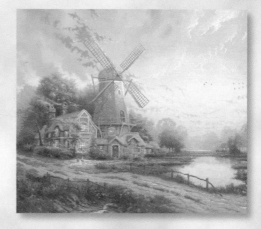

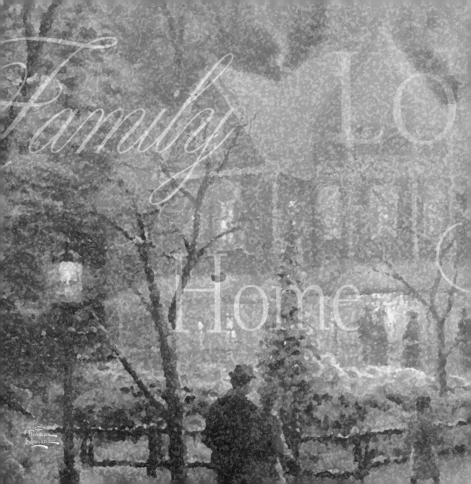